Several Clouds Colliding

BRIAN CATLING | IAIN SINCLAIR

SWEDENBORG ARCHIVE | BOOK WORKS

I once saw not far from me a meteor. I saw a cloud divided into little clouds, some of which were blue and some opaque. These I saw colliding, as it were, with one another. Rays flashed across them in the form of streaks appearing now sharp like the points of swords, now blunt like broken blades. These streaks now darted forwards, now retreated, exactly like pugilists. It seemed as though the varicoloured cloudlets were fighting with one another, but they were sporting. Since the meteor appeared to be not far away, I lifted up my eyes, and looking intently, saw boys, men, and old men entering a house which was built of marble with a substructure of porphyry. Above this house was the phenomenon which I had seen. Then, addressing one of those who were entering, I asked, 'What is going on there?' He answered: 'A gymnasium where young men are initiated into various matters pertaining to wisdom'.

EMANUEL SWEDENBORG

Contents

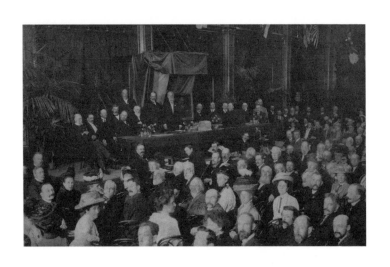

Eyes No Eyes
IAIN SINCLAIR

Werner Herzog, at a loose end in San Francisco, breathless from the absent hospitality of his patron, Francis Ford Coppola, and suffering from malarial tremors, fever dreams of encroaching jungle, took himself to the rock bastion of San Quentin. He was soothed, as he noted in his journal, by the 'linden-green' walls of the gas chamber, where so many infamous stars of *True Crime* newsreels played out their final scenes, eroticized and dissolved by the grudging inevitability of an antiquated chemistry. Gross intimacies are witnessed by implicated voyeurs who cloud a studded porthole with the breath of fear. We have the censored gaze. And colour going out of the eyes like airmail letters sent from secure wards to dead presidents. We have a complex and shocking exchange in real time. The serpentine hiss of pellets falling towards, but never achieving, a red fire bucket. Last words mimed for a disconnected microphone.

There are certain corridors, underground, within secret London buildings, where ceramic tiles from the Arts and Crafts era achieve an aquamarine luminescence, independent of gas lamps, electricity, or human intervention. The physics of attraction defies established rules. The tile wall is a shimmering stream. And the tipped floor of a *Sunset Boulevard* swimming pool. The researcher tries to filter out the hard information, dates and names, offered by his guide, the man with the key to the private library. The linden-green outwash of Herzog's anecdote evokes the sun-dappled avenues of a landlocked city. Coarse

1

uniforms. Bloody greatcoats against a Russian winter. Suggests gas-oven drownings: blistered mouths, lungs replaced by flaccid supermarket carrier bags. Oxygen bubbles breaking beneath the ice of choked oceans. The requirement? To sit, silent and solitary, at an oilcloth table, in the windowless room beneath the theatre, in the house that is a skull. 'Even the unthinkable', said Herzog, 'was expressed in numbers'.

The researcher has a simple task before him: to evaluate a group photograph from 1910, from another building. The man upstairs, the official archivist, could put names to most of the audience, along with potted biographies; curious details of the forgotten lives of respected citizens. But that is not what the researcher needs, not now, not within the plurality of this place, the still point in the life-support machine of a structure that is also a map of consciousness, a living breathing thing. In choosing to read Herzog's deranged Amazonian journal, he is importing lizards, saliva-enhanced gourd-drinks; chicken beaks amputated with hacksaws; crabby Hollywood veterans ensuring against failing heart-valves with rusty scrap-metal resuscitators salvaged from mud-sunk paddle-steamers and the shower blocks of punishment battalions.

I followed an electrical crackling and found in the wet wall little metal doors that were wide open, inside them a tangle of cables. Here we have the portals to death by electrocution...

The unacknowledged project was to translate mathematical formulae into language, the footprints of spectral lemurs into plain prose. The audience, formally dressed, men bareheaded, women extravagantly hatted, are in the King's Hall of the Holborn Restaurant—and also in Manáos at the Opera House, which Herzog described as being dropped from the stars, set down by rubber barons among a chaos of detonated shacks and rat-run boards. In Holborn, creepers smother dirty windows. On the Amazon, trams skid and stall, lines disappearing into impenetrable foliage. Bats swoop on straw hats. Parrots shriek on Underground platforms. Divas

tremble on cardboard mountains. The high table, draped in velvet like a coffin, is launched into the vortex of the rapids. They turn, all of them, away from the stage, away from the dumbfounded notables; with grave, rheumatic twisting of neck fibres, they face that impossible transformation, from London séance to tropical madness. The moustaches, the beards, a beach of pebbled skulls, swivelling, straining—apart from one woman—to witness this *King Kong* invasion, the beast of ignorance, the unashamed priapic monster who is not there, nor ever was. Rear wall dissolving into mirror.

The room leaked. Droplets of ghost milk, sugary and sweet, expressed from the cracked ceiling, dripping on oilcloth. A liquid border, emphasized by suckling flies, around the Xeroxed photograph of the King's Hall disciples. Nothing to add. Much to undo. The enlarged version, cropped and captioned, remains on the stairs, giving pause to newcomers, as they ascend towards official business in an upper chamber, among the staid books and accidental papers. It was the researcher's belief that the Edwardian photograph was now a window. That his own face, flushed and hard-breathing, was the horror revealed to the quiet crowd in the phosphorous flash of the hooded tripod. A superstitious flutter of mortality, and the knowledge that the house is constructed as a series of rafts and platforms for the undead, conjures its own sound effects: a heavy curtain being dragged back, somewhere overhead, to reveal a bare brick barrier. Muffled applause is absorbed into the creaking of water pipes. They stamp on the ceiling with black boots. The plink-plink of milky, rubber-sap on to the circle of the oilcloth table becomes an insatiable torrent, honey mixed with dust-dry plaster. Touch it and the skin is burnt from your fingers. Taste it and your tongue frogs and swells.

Dulled by the limitations of the ostensible subject of his investigation— the photograph of the Swedenborgian Congress from 1910—the researcher is blocked by unwanted data. He tries to forget everything he has been told. Invented stories open fresh neural pathways, recalibrate psychopathology. Recitations of confirmed facts, dates, newspaper

obituaries, acts of conspicuous charity, close down the potential for fruitful speculation: new continents, new meanings. If we cannot rewrite the past, we have no future. Look at the captured palm trees, look at the spiny articulation. The Amazon was here before they knew it. Look at the hungry yucca. Listen to its song. Flesh-eating plants on the edge of the platform. These men are the residue of investment: cigar ash and malignant dandruff. It is the researcher's task to obliterate the introductory lecture provided by the keyholder: let the bearded portrait, in its obscure corner, return to the shadows. The dust-crowned marble bust of the worthy woman should remain as unknown as a figure in a Hastings junkshop. The interconnecting door to the other part of the house, to the Swedenborgian fundamentalists, is locked. The glass-fronted book cabinets will never be opened. There is a tin trunk with a fraudulent date, years before the Society was named and chartered: white letters on a black surface.

The researcher was closed to the discourse of angels. End of story. He flipped the lid of his laptop and slid in a disc: Fritz Lang's *Dr Mabuse der Spieler*. That extraordinary scene, now enacted on the floor above him, in the empty theatre, a mesmerist drawing back a curtain to allow a procession of Egyptian priests, soldiers, camels, to pass through the wall and down among the audience. The expressions of the spectators, in formal attire, are frozen, so that a comparison can be made with the hypnotized mob in the King's Hall. Discriminations of hysterical paralysis. Some of the women attempt a half-smile of social convention. The men look as if they have been slapped with a wet kipper. A well-known society essayist, unmarried, of a certain age, goes into spontaneous labour.

This is going nowhere, open the trunk. Nervous of intervention, the researcher swoops on a gathering of brown envelopes, pamphlets, leather-bound books. Now there is a sense of urgency, that this material must be examined, filleted, assessed, before the snoop can be released from the subterranean meeting room. As he unties the string on the first packet, he is aware of the walls closing in, multiple images on the

dirty glass enclosing the shelves of dull books. He transcribes random fragments in the unfounded expectation that they will link up, cohere.

A fardel of stories, and of personages, and of emotions, inseparable from the first expression, passed from generation to generation by poets and painters...The invisible gates would open as they opened for Blake, as they opened for Boehme...A world of spirits where there was scenery like that of earth...An author not of a book but of an index...A muse with a lyre like one of those Angels in Swedenborg's vision...Permanent near-death experience...I was in London, preceded by dreams...My only business is to discover Satan wherever he lurks, to deceive me into his pernicious society...It must be bad, for I recollect when I found him out in Dorset Street, and for some time after, he behaved very civil...John Wright, having a great burthen upon him, was led to take a walk all the way from Dorset Street into Kensington Gardens, where he hung his hat upon a tree, immediately the burthen left him...I espied out a crazy old boat, fastened on the shore on my side of the torrent, but with all so very shattered, that it seemed to take water on all sides...You must further know, that it shall be given to you to be one of the greatest surgeons in the age, and I am now sent to give you instruction in the art: then pulling out a Morocco pocket-book from her pocket, she took from it a piece of paper, on which was delineated the representation of an Abscessed Tumour...*A most beautiful woman dressed all in white...But in March 1776, calling accidentally on the narrow part of Holborn, near St Giles's, at a little booksellers, one Mac by name, to ask for the* Behmen's *books, viz.* De Signature Rerum, *he had it not; but he told me he could let me have another, perhaps full as curious...As for the author, replied he, he died here but very lately; his name is* Emanuel Swedenborg. What, *I replied hastily, recollecting what Mr Peacock had told me concerning him,* that madman, who pretended to confine Angels and Spirits in bottles? *That very man, answered the Bookseller, with a smile; and the book in question is but half a crown...While the Count never spoke openly of*

the great secret possessed by the Avignon Society, towards the end of his stay in London he did impart it to me and two individuals…My numbers are 3-7-3…The ceremony was a long one, and they were not again in the city until dusk…O that mine enemy would write a book…The Holy Spirit bid me speak to a man who was sitting at some little distance from me. I found him to be a converted Jew, whose name was Samuel…We met every evening, at seven o'clock, to commemorate the death of our Lord and Saviour Jesus Christ, by eating bread and drinking wine. Very often, when we have been sitting together, the furniture in the room has been shook, as though it was all coming to pieces; and upon enquiring what was the cause, we were told, that it announced the presence of angels…

Unearned, from within that tin trunk, there was a tale to be assembled. But the researcher was only too well aware that it could be told in any order, that the witnesses were unreliable and the punctuation rudimentary. He was trembling. He took out his flask and gulped down a hit of the fiery spirits. He gripped the edge of the table; it was shuddering, responding to a train in some underground tunnel, an effect he had not previously noticed, caught up as he was with the trespass of his inspection of the cache of faded typescripts and musty originals.

Reading rapidly, skipping and swooping, the researcher went through the material for a second time. From eighteenth-century letters to Golden Dawn fabrications. From scholarly winnowings to ecstatic revelation: WB Yeats, Helena Petrovna Blavatsky, Annie Horniman, Samuel Liddell (MacGregor) Mathers, Dr William Wynn Westcott, Aleister Crowley, Cagliostro. Certain paths. Particular journeys and occult pilgrimages. Unexplained clusters in the south London suburbs. The story eddied around the Swedenborgian Rite of the Masons, as refined and practised by the Avignon Society. A Blackpool medic, a general practitioner with time on his hands, a man called Thomas Carr, produced, in the third year of the First War, a series of unpaginated typewritten notes. He listed the hidden groups who kept alive the Swedenborgian Rite, with

the Illuminati of Avignon given pre-eminence. There were others, in London and Narbonne. He named John Yarker. And Dr Wynn Westcott, Coroner for Central London, the person who succeeded Yarker as Grand Master of the Swedenborgian Rite. 'In later years Brother Yarker fell on evil days,' Carr wrote. 'And many outside degrees with which he was associated died of inanition. They are never worked now.' A scan of photocopied membership lists for Primitive or Swedenborgian Rite Freemasonry reveals: Brother John Yarker, Supreme Grand Master; Brother Wynn Westcott, Past Master; Brother AE Waite, Marshall. 'The Rite consists of Three Degrees, to which craft Master Masons, in lawful and regular possession of Symbolic Masonry, can alone be admitted.'

From an overlapping and contradictory mess of documentation, key figures emerge, key locations. The researcher begins to understand: it was not that Swedenborg brought a vision and a doctrine to London, a resource for the moustaches and plate-sized hats of the King's Hall, it was London that activated an idling machine. Movement from river to tributary, Wapping to Fetter Lane, manacled the prophet to specifics of place: he articulated earth-truth, secrets buried in shallow graves. Legions of the wandering dead brush against our shoulders, dry leaves over gravel, shreds of black plastic on razor-wire; whispers and echoes in empty churches and wasteground sheds. All the languages of heaven, lost and still to be invented. The ladies in the audience, like beekeepers, their hats keeping the foul insinuations of spirits, mosquito-fairies and freaks, out of tight mouths and stiff hair. The men are relief carvings, medallions on their own Nunhead monuments. As we move, so we become part of the great narrative stream. Swedenborg understood the correspondences: *where* not what. The house, the room, the box. He invents his own submarine. He hears the generators that shake the table at which the researcher sits scribbling in a red notebook.

Benedict Chastanier: *A Word of Advice to a Benighted Society*. 'The Avignon Society is the Synagogue of Satan.' The quest-journey across pre-revolutionary France, among clerks, encyclopaedists, spoiled priests

in greasy soutanes. 'When he got to Avignon, he gave himself up to be instructed by jugglers.' Chastanier, like so many others, is preceded into London by his dreams; beyond anything this is a dream-city, old stone crusted with fossil forms, the fog of willed ignorance. The first confused walk is already a shudder of recognitions. He sees the crocodile behind the louse-ridden wig. He sees the horse-skull dipping into mutton broth. There is a crazy old boat, you'd be crazy to climb aboard, tethered to a skeletal Limehouse jetty. He sits, shaking, in his chamber, greedy with ambition, raging against time, the guttering candle—when the eidolon, the woman at his elbow, produces a Morocco pocket-book. He will be a surgeon. Before the bells of St Giles sound the Angelus, a boy delivers a set of surgical instruments, curved slaughterhouse blades, bound with twine, wrapped in oilskin. *Abscessed Tumours*. The voice said: *Northampton*. Enclosed parkland. An asylum. You must found a professional establishment, a college of initiates. He hesitated, he kept to London. There was much to unravel. He dined, he attended. He tasted ridged claws, pressed lips to palsied hands. The moment was not propitious. He was published in Spitalfields by Mr Hawes. There was a pattern, an equation, numbers into words: dates that were not yet come to fruition. Centuries curled in grains of sand. 'See what success Dr John Dee and Edward Kelly had formerly, in establishing a communication of this nature, between the inhabitants of the Spiritual World and themselves by means of a *Magical Chrystal*, which to them, was something similar to the *Urim* and *Thummim* of the present Avignon Society.' He carved fruit. And took the confession of harlots.

Abbot Antoine Joseph Pernety: born 1716. Orthodox attachments to unorthodox persuasions. Animal magnetism, somnambulism, magnetic healing. 1779: Berlin. Discovers *Conjugial Love* by Emanuel Swedenborg. The double's double. He is appointed librarian to Frederick the Great, who mistakes him for his cousin, Abbé Pernetti. He makes the acquaintance of Count Thaddeus Leszczy Grabianka. 1786: Sociéte des Illuminés d'Avignon. (Female chorus depicted, years later, from the local brothel and a rack of tribal masks, by Pablo Picasso.) A person in

Podolia, bordering on the east of Galicia, then part of Poland, is brought back from the dead. Thin fire on a frozen lake. A peasant in Moldavia rises from his grave with 'the impression of a spear and a cross indelibly marked on his breast'. Grabianka is also known, in Paris, Rome, London, as Gabienska, Grabianca, Soudkoski, Soudkowski. He publishes an account of 'the Formation of the Mago Cabbalistic Society, now residing at Avignon'. The Count, on the point of departure for France, boasts of a great secret, which he will impart to two individuals in London.

Cagliostro sang. His lips curved themselves into bows, and ever wilder and wilder noises proceeded from them. The bubbling fullness within him, the turbulence of his senses, compelled him to sing. Cagliostro sang. He sang dissolute litanies and harp-ditties of his native pot-houses, the gallant canzonets and chants of his childhood days, the ballads of his most edifying pranks. Cagliostro sang, wildly and all out of tune. And he was unspeakably happy.

The two men, separately, and without knowledge, one of the other, walked to London, down the road Chastanier failed to take. In the vicinity of Northampton, they paused beside a steepling monument to a dead queen who had made the same journey, dreaming England into existence. A sort of cheese-stone spire broken from a church. As if a great cathedral had been buried on this slope and was slowly rising from the ground as floodwaters fell away. As if the succeeding monuments were decorations on a mysterious crown. And that these carved pillars never changed, but accompanied them, so that at each evening's halt the sun went down and only the backdrop altered, like a theatre of memory: *while the monument was always the same.* Beyond Bedford, William Bryan, dust in eyes, print swimming, read Chastanier as Christanier. As *Christian.* 'I looked, and saw him open a book, and read therein; and, as he read, he wept, and trembled'. Bryan's shadow, John Wright, a carpenter from Leeds, carried a book in his hand as he walked. His guardian angel was named and the name was *Assadai.* Which he had of Abbot Pernety when he lodged in Dorset Street. And which was discovered

9

unto him when he hung his hat upon a tree in Kensington Gardens. William Bryan, a copper-plate printer, falling into conversation with a converted Jew called Samuel, found employment in Spitalfields. When their hour came, in company, the two men took sail for France and travelled, after a short respite in Paris, on foot to Avignon. Where they were initiated in 1789. The ceremony was a long one and they were not again into the city, which shivered and shook, as if in the path of some extraordinary seismic event, until dusk. When they broke bread and drank sour wine with their sullen and silent companions in the yellow house. The brothers whose ears had been cropped to the root.

Though the pulsing strip-lights offered no indication of the passage of time, the researcher recognized that he had used up his permissions. The sounds in the building were more acute, now that the archivists, secretaries and scholars, had left to return to their quiet suburbs. The researcher's head throbbed. The weight of the uncatalogued relics, bones, rings, baskets, faint impressions on glass slides, oppressed him, walled him in, squeezing from every direction. The narrative of London, buried alive in that black tin trunk, was a Mappa Mundi. All of these characters with their exotic, shifting names and rigid, mask-like faces played their part in the formulation of the infinite novel. It starts in sleep, those permanent near-death experiences, sexualized glimpses of obscure locations, Georgian buildings, spidery postcards, bundles of manuscripts hidden on street stalls in threatened markets: *come here, come to this house, sit in my chair.* The horrors, the botched ritual sacrifices, are rehearsed so many times that when some brutalized psychopath enacts them they are redundant. The same addresses. The same walk down streets with names made new at the whim of fashion and political correctness. The coroner, picking through autopsy reports, interrogating dubious witnesses, re-composes a crime that has not yet happened. In giving form and authority to a shambles of unedited gothic anecdotes, he approves the text of the city. He extracts *author* from authority, *doxy* from orthodoxy. Writer and prostitute. *Writer as prostitute.* A marriage of convenience. An alchemical alliance. Angels and spirits in bottles.

Dr William Wynn Westcott, alleged suspect, named in numerous articles, mainly of West Country origin. He revelled in societies which purported to initiate members in mysterious or occult lore. A Freemason, a leading member of the Society of Rosicrucians, an associate of HP Blavatsky. In 1887-88 Westcott joined with Samuel Liddell Mathers and Dr William Robert Woodman to found an occult society: the Order of the Golden Dawn (originally the Isis-Urania Temple of the Golden Dawn in the Outer). Its membership included Arthur Machen, Algernon Blackwood, WB Yeats, Annie Horniman. Some peculiar attempts to raise 'spirits' and even 'evil powers' were practised, but this did not become the dominant feature of the society until Aleister Crowley joined it in 1898, whereupon his ambitions and ties to Mathers hastened its dissolution.

Tea. Hills and mounds of drying leaves. Terraces and paddies of south London suburbia. An empire of crescents and fishbone tributaries branching and rebranching in dying winter sunlight. Denmark Hill and Forest Hill. Dulwich and Peckham Rye. Ceylon and Assam. Verandahs. Conservatories. Post-colonial villas. Frederick John Horniman. His illegitimate bounty sold in tins and packets. 'Pure and delicious.' His neighbour traded in whale oil, boiling blubber in reeking vats on Bugsby's Marshes, and used the profit to commission whaling-voyage art by JMW Turner. There was a thirst for bones, for carvings, feathers, Day of the Dead vodun wax and tin. Fortunes measured in salvage, in sacks of tribal fetishes, mummy cases, torture chairs of the Spanish Inquisition reassembled in Whitechapel smithies. A slogan for the times, for the trade: 'A Right Royal Drink!' Coded for initiates. A secret embossed for the verminous multitudes, the bankers' clerks and remittance men of Carshalton and Upper Norwood. *Royal rite.* Inebriated princelings. Rituals of the Royal Arch. Tea and sympathy. Annie Horniman appoints Mathers to curate her father's cabinet of curiosities, the madness that overwhelms the family home, *Surrey House*, forcing them to relocate. Closed down, shuttered, demolished. The museum on the hill: its mural like the screen of a cod-Egyptian cinema, its succulent curves and pillars. A blunt tower carved out of buttermilk.

It was time to put away the papers, return them to the black tin trunk. Look on this receptacle as a word-block, another loose-leaf accumulation, a forbidden book composed by its only reader. Researcher as coroner: death by misadventure, while the balance of the mind was disturbed by place and circumstance. Overworked, underpaid. Undernourished, overstimulated. Too many cups of brown-slop tea. A photograph, burnt out, ill-composed, bent, as ancient as the faded typescripts, falls on the table. That glass-case mummy, the hieroglyphics, he knew them: from the Horniman Museum. And the man in the suit? The horror of that. Like the frozen audience in the King's Hall at the moment of the blinding explosion of light, walls turning to glass, bomb outrages from some remote future. He recognizes this person, his outline, but does not know him: some lost younger self. Was he ever on that side of the river, on that hill? The double's double. *The invisible gates would open as they opened for Blake, as they opened for Boehme.* The photograph grounds him in a room he has no memory of visiting. A journey across London curated by angels. Down through a park which transposes with another, a dream of Paris. *Among all the sacred places which, like nodal points of human thought, express in a wholly concrete form specific aspects of a few great supernatural ideas, I imagine that a pagan, I mean a man capable of responding to the mysterious novelty of an idol, is likely to prefer those places which have become assigned to Violent Death, that divinity who brandishes the axe lashed to a bundle of firewood.* Hermaphrodite angels smothered in ivy. Their gestures. Warding off sunlight: Camberwell Old Cemetery. Angel-trees of Peckham Rye. Maquettes of idols with aeroplane wings in the studios of public sculptors. *A tree filled with angels, bright angelic wings bespangling every bough like stars.*

By floating, without resistance, no premeditation, no maps or charts, no documentation, no cameras, the city writes you, rights itself, rites of virgin memory. First days in an old landscape. With soft winds, innocent thefts and quotations, walking like ghosts, without the burden of gravity, hat on tree, we come to the house which is a skull, to the basement, to

the black box. We return the papers to their quietude. The researcher, reaching into the tin trunk, reaches into his own portrait, collapses time; so that, like the Swedenborgian audience, like Swedenborg himself, he is pulled through and out, observer and observed. He has no weight or form. He is the reproduction of the reproduction. And the papers, as he returns them to their regulated darkness, settle in the trunk within the trunk. He is tired, he curls like a grub. He lets the lid fall. Tin ceiling loaded with extinguished stars. Falling and closing. On the house within the house, its curious and schizophrenic design, two houses brought together. He shelters in the enfeebled image, the record of a casual excursion to a room with no tolerance of foolish tourism. The black tin trunk contains a model of the Bloomsbury house as real as the original. And within that? Another basement, another trunk, another house. And within that? Another trunk containing another house. And within that? A random accumulation of papers. A pillow for a photograph in which a researcher sleeps, in permanent near-death suspension, dreaming himself into the blinded audience. A person whose ear is sliced off by the fold in the printed paper. An entity sliding from a photographic plate, secure in a wooden tray, in a sealed basement, in a shuddering house. A thing whose number is 3-7-3.

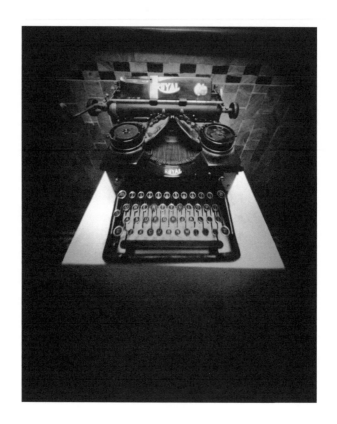

Commentaries

IAIN SINCLAIR

THE TYPEWRITER

A scaphocephalic X-ray: top-heavy. The bloodshot reels are tin eyes. Pince-nez of ribbon, legion of dishonour. Rictal mouth in a mash of metallic teeth, Germany dentistry. Or: stand the thing on its head and the keys become strokes of electrified hair. Shock therapy. One scarlet lip, bitten and bloody. And the other? Black as human ignorance. Bridled, the scold who has swallowed her own children. The typewriter, long out of service, dictates the screenplay: *Bring Me the Head of Emanuel Swedenborg*. Stripped of flesh, this instrument is our first skull. It vibrates like a skin drum. An empty cranium filled with wormcasts. It writes the long house into being, as a form of apology; architect of its own ruin. Fingered to erotic frenzy, it talks code. The truths of the sense of the letter of the Word…are found in dumb receptacles.

Provenance unknown. Thought to be in use for matters of business until the coming of the word-processor. In essence, a memory-device waiting to be activated; to reveal, without human intervention, all the secrets of its infinite interior.

THE WICKER BASKET

First cousin to the Wicker Man. An instrument of immaculate and uncalculated surrealism. Neither hidden, nor found. Probably in place before the house was constructed. An equation purer than the collision

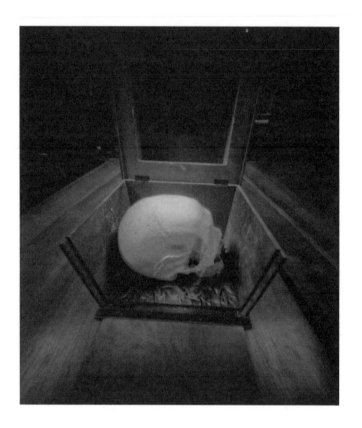

of the sewing machine and the umbrella on the operating table. The walking stick becomes a handle and also a spine. Without its crowning skull, the basket is a device that belongs at the foot of a domestic guillotine, a bin for the transportation of recently harvested heads. Vodou fruit. Golden wickerwork, woven as therapy by a quorum of the criminally insane, has been rendered harmless and benign by lengthy residence in this admirably discrete London property.

Provenance unknown. Previously unrecorded. An object outside history. Not so much lost as mutated: the posthumous form of a forgotten woman in a masculine building. Dust-dry and slightly waxed in protection against the prevailing microclimate of damp tweed, old leather, moulting marble. Attics where scholars calibrate the scrapings of mute tongues. Bare legs, like chickens, beneath oak tables.

HEAD OF A WRONG MAN

The iced dome solicits fingerprints. Here is the borderland of Cesare Lombroso's system of taxonomy, a relief model floating somewhere between kitchen and path lab; cake or helmet. A study in tensile anxiety: Atlas of the Criminal Classes. That German sleepwalker, who never escapes the confines of his own skull, is also called Cesare. The box in which the second cast of the head is kept—the head which is not the head of Emanuel Swedenborg—becomes *Das Kabinett des Dr Caligari*. Bloomsbury as Prague (as Prague, much later, will become Whitechapel for those who are determined to invade the past with industrial technology tested in Iraq). That city where reality fuses with dreams, and dreams turn into visions of horror. One evening in October 1913 this young poet was strolling through a fair...

The trophy contrives multiple and conflicting narratives. The sack Warren Oates left behind the bar in the Crown and Dolphin bred flies with the gift of language, dung-feet dancing cuneiform messages into foul linen. The white skull puffs on a black cigar. Close the lid and the

light goes out. Loose talk costs lives. Plaster dribbles from a detached jaw. One bone brought down the temple. A kingdom of ends and uses.

An object of proven ambiguity, pivotal to a raft of painstakingly documented fictions. Published in red-letter Latin. A much-travelled memento of the classic era of phrenology. Swedenborg's low brow was built up, postmortem. In old age he grew milk teeth. A ridge-like vertex and more or less complete fusion of the parietal bones. A limited edition artwork multiplied by resurrectionists, naval officers with an eye to the main chance, Celtic antiquarians, released Cable Street lunatics. 'There issued forth effluvia in such abundance and of such a sort that candles went out, and all the observers were obliged to rush head over heels out of the burial vault in order not to be smothered.'

THE VOYAGE

The head is now ordnance, a cannon ball, a trophy returned, with full naval honours, to the amnesia of its native soil. It sings against cold air. The Swedish newsreel unravels in static tableaux anticipating a form of cinema that is still to be invented. Emanuel Swedenborg has described the process in technical papers buried within the confines of Wellclose Square; scientist, diplomat, spook-speaker. Film, that persuasion of dead moments, runs backwards, like time. Until ghosts slide out of the blank connectives. And the steel-grey warship, rivetted in stiff emulsion, becomes a coffin boat, the wooden hulk fetching this young man to London. A plague ship from which he slips ashore, close to the patch of ground where, years later, he will be buried. And reburied. Excavated. Examined for traces of a crime not yet committed. The mystery gnaws its way out of the preserved shell, into the mist, the river fret, the stink of sheep cases ameliorated by cinnamon. A Viking funeral for invaders opting for political neutrality. Iron ore crosses the frontier into German forests. Railways are mortal ladders.

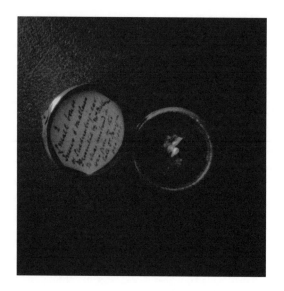

A memorial album buried in a private building. A record that belongs in the black ark, depicted in low relief, on the chipped font of the old Swedish Church. A stone craft like a floating cathedral. Aligned with Hawksmoor's hollow shell and the severed caput of Williams, the Ratcliffe Highway killer.

'The little green oasis, in the desert of bricks and poverty lying between Whitechapel and the river, was the scene yesterday of a strange ceremony, the beginning of Emanuel Swedenborg's last journey to his first home.'

1908: passage booked on a destroyer, *Fulgia*. Welcomed to Uppsala by 3,500 singing children. Granite sepulchre with owl and snake, cherub and scales. Confirmation of absence. An elaborate device to silence the excited tongue. Words are inscribed on the whole man, so that, in the gas-lit corridors of eternity, he may be read like an open book.

RELICS

Three items, from deep cover, drawing strength from their random conjunction. A dangerous equation: bone, wax, hair. The archivist helps to invent a plausible history: 'My guess is that the ear bone and the piece of hair were both taken away as souvenirs by people who attended the ceremony to place Swedenborg's skull back in his casket in—I think—1820.'

The skull was stolen in 1816 or 1817. The coffin was not re-sealed after the original violation by an American Rosicrucian, who entered the crypt attended by a small entourage. The relics, liberated from their confinement, passed through numerous hands, acquiring legends of their own, independent of source.

Inscription on box: 'Small bones incus & malleus of Swedenborg's ear. Presented by Mrs Bateman to whose husband it was given by the late Dr Spurgin, Dec 1880.'

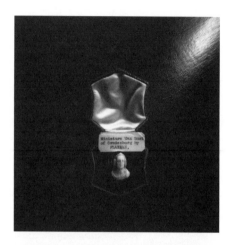

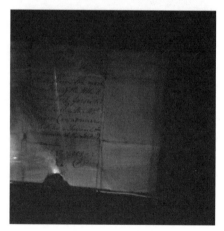

Slender bone: snorted as snuff. Wax quilled from fleshy vortex of Swedenborg's ear and pressed into a delicate likeness of the philosopher. Flaxman, Waxman: *House of Wax*. 3-D epic by André de Toth. Tooth fairy. Skin writer. *Mystery of the Wax Museum*. Stitch a mirror-suit out of ears and tongues. And bury it at the tideline. Chained to the river.

Spurgin died after a violent assault that aggravated the fallible condition of his heart. An interest in Swedenborg ripened during his medical apprenticeship in Yorkshire. Coming south, and crossing the Thames, Spurgin was attached to Guy's Hospital, where he made the acquaintance of John Keats, a poet. A blood-lipped kisser of handkerchiefs.

The yellow hair in its condiment sachet is a post-mortem slide. Hair in the gate of the spirit lamp, the biological projector. It butters archival illumination and slips the enquiring fingers. DNA confirms the ability to seed a slope of white plaster. Every strand a bookmark. Every book a last will and testament. The holiness of the heart's affections.

Mrs Dunn, on paper headed 'Pentonville', authenticated the hair as coming from the mortal remains of E Swedenborg. Lime pits of executed murderers, wax museum celebrities. The full ownership provenance is: Charles Augustus Tulk, Joseph Clover, Thomas Hiller, Mrs Dunn, JR Boyle, Revd ER Goldsack.

ANNOTATIONS BY SAMUEL TAYLOR COLERIDGE

The text, proofed and polished, builds itself around a cluster of spidery annotations. Bug-ink leaks into illustration, allotments of morbid anatomy. Coleridge, with his attendant minder, over-prepared lectures he was unfit to deliver. He transcribed published materials and made them his own by acts of generous plagiarism. Table-talk got the table talking. He thickened and spilled, drooling port wine laced with opiate syrups.

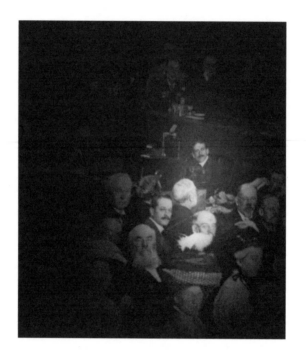

De Quincey watched in horror, saving his revenge for the banishment of Edinburgh, as Wordsworth cut virgin leaves of Burke with a butter knife 'that left its greasy honours behind it upon every page: and are they not there to this day?'

Coleridge's annotations to Swedenborg's OECONOMIA REGNI ANIMALIS IN TRANSACTIONES DIVISA...Amsterdam, 1741.

'How can I explain the fact, that it should have been possible for Swedenborg not to have detected the entire absence of any specific meaning in the word, Fluidum Spirituosum, as the Subject of Life, thought, Will? He might have substituted x y z, as expressions of an unknown quantity, or a somewhat! But that Sw. should have craved an image, a superficies, i.e. Facies superfacens, for a substans!! The best plan will be to omit the term, Fluidum, altogether.'

The translation of Swedenborg is by Augustus Clissold. The translation of Coleridge is by Coleridge. Trembling and frost-bitten against a low blue moon.

THE CROWD

An audience attending to dissolution is dissolved. Think of the printed portrait, the scale, the detail, as a paper mirror. The Bloomsbury hats, waiting on spirits, on revelation, are suddenly aware that it is not to be found on the stage in front of them but away to the side, to the left. Is that Robert Louis Stevenson? A consumptive gunslinger behind a Spanish moustache? Has Arnold Bennett looked in, after a fish-omelette dinner, from which he can still suck the odd bone? They twist and turn on hard chairs. Dark clothes provide a suitable drape for this tapestry of solarized heads, fleshed bulbs, cups with eyes. The octopus emerges from its celluloid collar. Frame any dozen or so attendees and you have a small masterpiece of nervous movement; the straining, the slipped focus, frozen instants of pin-sharp attention. The curved backs of the chairs are spinal whips recorded in Swedenborg's anatomy primer. As the explosion

happens, in the powder flash and afterburn of violet haloes, the wall goes down, so that this mob, civilized, well-intentioned, locates its other self, away to the east, from which foul winds come, in the Bishopsgate Institute. London, suddenly, in lecture halls with their stages and curved swimming-bath ceilings, stares at itself, audience looking at audience looking at audience. A nanosecond infinitely prolonged. To be studied like a Mappa Mundi. An earthquake in China. Photograph collapses into photograph. The prophecy is fulfilled. And the stage, when they return to it, is empty, prepared for a silken execution.

CLISSOLD

A biography in brass: the man who becomes a park. An important staging post on the mythical Northwest Passage, the way out of London's temporal fix, glimpsed by Thomas De Quincey, experienced by Edgar Allan Poe, made fabulous by Arthur Machen. A sponge of buried rivers. Removed to another continent, Poe understood how the system works: by splitting, by cell division, by spectral duplication. The park, with its undergrowth, is a changing room for doppelgängers. A skein of disbelief walks away from the seated clergyman, bandaged in orthodoxy. A portrait pins him like a butterfly.

The ridged memorial plaque, lettering shaped like the imprint of a man, is a tomb set into the panels of the wall; vertical corpse, munificent patron, enabler of property.

Wales, London: Machen, Robert Frank. The head of Bran sunk into Tower Hill. Augustus Clissold is a curate in Stoke Newington, a 'misty looking village', where he courts Eliza, daughter of the fearsome iron-master, William Crawshay of Cyfarthfa, Merthyr Tydfil. Iron for the guns of *HMS Victory*. Crawshay says that he will shoot on sight messengers employed by the lovers. He builds a wall with foundations ten feet deep to prevent the sexton sliding surreptitious coffins on to his estate. Clissold waited, Crawshay died; Eliza inherited the Stoke Newington mansion and a considerable fortune. Clergyman married heiress. In the lost years, he read Swedenborg. Now he promotes him. Relatives seethed as

the Crawshay thousands were diverted into Bloomsbury, a receptacle for the New Church, its devotees and relics.

Clissold lived, so it was said, in his library: which is now a tea room for park casuals, mothers and children.

While assisting, however, to the utmost of his ability the uses performed by those who are striving to enter into the New Jerusalem through the three gates on the south, he never forgot to care as well for the spiritual wants of those who are approaching the Holy City on the north and on the west, and who are labouring to enter into the city through its three gates on the north, and through its three gates on the west.

April 6th 1744

BRIAN CATLING

The rain fell solidly through a London that was losing its temperature in the latter half of a long winter. The prophet hurried to the *appointed* with a vision that he had never expected to meet, hurried within an hour's walk from where we are now. The rain beat against the relentless grain of the hard stone that had been profiled in grandeur. Outside that, it sucked and spat at poverty's fringe, easing the haggard mortar aside and saturating the glassless windows. All the puddles boiled with the impact of the stair-rod deluge, as did the surface of the Thames, a frenzy of hissing water over the muscular weight of its moon-driven tide.

The tavern glowed against the rain, a steam of sound and cooking curling around it. The prophet shook himself once inside and asked for a closed booth; he was in no mood to engage in conversation. The toothless waiter strained to understand his accent while nodding to indicate that he did. Eventually after much pointing he found a space shuttered on three sides and settled into its solid furnishing after explaining what he did, and did not, want to eat. The alcove was warm and lit by candles. Light also spilled in over the thin wooden screen from the rest of the noisy inn.

The same waiter arrived with a piled platter and slid it before the seated man. It was only after his third mouthful that he looked up to absently take in his surroundings. As he did so there was a change in the thick air. The sound of the place and its light seemed to diminish, or rather, it began to turn itself inside out. He let his hand fall to the

table, the fork in it striking the hard surface without a sound. He stopped chewing, his jaw slack. The light had almost gone, even though he could see the flame of the candle, which now was a sable shadow. Every particle of energy had inverted, its lining now visible like the dark silk of a richly embodied coat. The interior of sound wore its silence over any trace of the colour of its previous volume. Even the rain scratching at the leaden window had changed. A static rigidity filled the room without the modesty or demeanour of silence. The soon-to-be prophet became frozen in fear. Firstly by the unnatural strangeness and secondly by his knowledge of brain seizures. He had looked inside the skull, understood its boltings onto the spine. He had lifted and fingered the inertia and speculated about the seat of sanity in grey mass. The food and his voice were welded together and his eyes strained the darkness when something moved before him. A presence that watched him. After a moment of not wanting to see it, of not wanting to acknowledge its existence inside his mind, it spoke. The words were clear but a long way off and without the slightest trace of emotional meaning. The speaker was visible just across the room. It appeared flat, more like a shadow than a form. Its undulations, giving the impression of features, did not stand out but skulked and slid inside the wall rather than standing before it. The words unlocked his mouth and made him swallow, unlatching the tension, letting normality begin to wear the surfaces of the room again. The flame slid back and noise gushed under the sickly absence.

He instantly bolted, shuddering coins, his topcoat near the door. The night glistened, shining, still without the cuts of rain bending the distance in which he ran. It was already there awaiting his return. But now without the miasma of fear. It spoke again in a softer more human voice.

'I AM THE LORD', it said.

There would be many other meetings with it. Conversations through the night. Revelations and wonders, but nothing like the first confrontation. The prophet never entered that tavern again and would find himself taking all manner of difficult routes to avoid the street that housed it. The taste of the darkness and the incandescent light, that the being now shed, never left his memory.

For he could not banish the ligaments and dimensions of his enclosure. It was as if the room had taken some of his light in its boxed obscurity, as if it had been squeezed through the aperture of the apparition and the banality of its words. Pulled through the bluntness and spread thin on the walls. Inverted and forever without movement. He had wanted to ask THE LORD if he was the same manifestation as that night. Could this divinity really be that crudity or had his perception been remodelled, reshaped to receive the magnificence of its spectrum. But he could never find the words to walk back through the rain and decided it better to live with the picture, his lack of appetite and the sound of the command still exposing his past times. The first sound of erudition echoing forever:

'DON'T EAT TOO MUCH'.

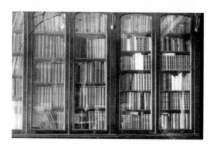

Lantern Slides

BRIAN CATLING

These images of Swedenborg's library are among hundreds caught in the dimming stiffness of a collection of glass lantern slides that live in a locked room below the Swedenborg Society's lecture hall. Primarily a teaching collection, with a strong emphasis on the history of the Society, it is also the largest and most copied collection of pictures of the prophet's earthly remains being escorted from one state ceremony to another.

But there are others.

Many are transforming in that glorious condition normally described as decay. Transforming through splinter and chemical imbalance. By fading and forgetfulness.

And by the unstable guile of history itself. All the slides are handmade preparatory works. Miniatures of natural science that by the irreverent sublime action of coincidence, now makes them appear like works of contemporary art. The careful gluing of tape and the painting of thick black masking paint (all processes designed to make the audience focus on the given area of illustration) now look like an aesthetic interplay between manipulation and mystery in an area already deeply signified by surrealism and the associative invention of water and glass/fossils/magnetic influence/pituitary gland/chinese pavilions/orbiting moons/beekeeping tools/crystals/machines . . .

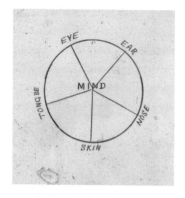

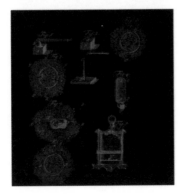

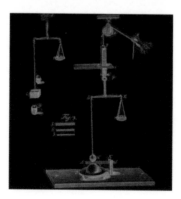

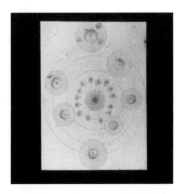

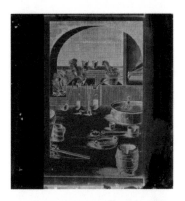

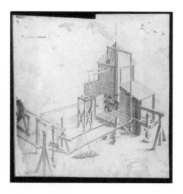

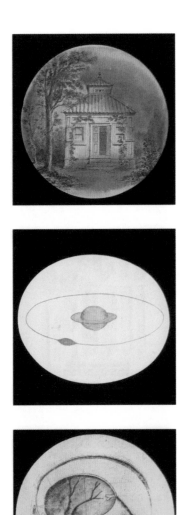

49

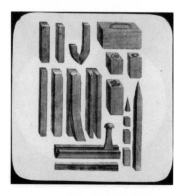

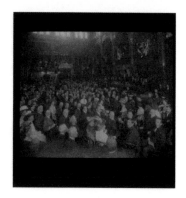

Faces

BRIAN CATLING

I am sitting at a wooden table on the stage. As the isolated images
of the faces from the old photograph of a Swedenborgian gathering
are projected in the dark, their after-images bloom and blur in our
unsuspecting audiences. Iain Sinclair steps into their gaze and turns
a disposable instamatic camera onto their faces; taking flash portraits
until the film is used up. He then passes the camera up to me and I
smash it to pieces with a glass crystal ball. Extract the exposed film and
eating it. When it is swallowed I drink some water and again quote what
the spirit in the tavern first said to the prophet: 'Don't eat too much'.

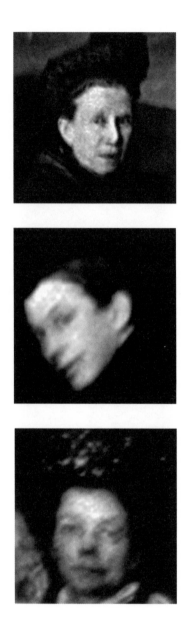

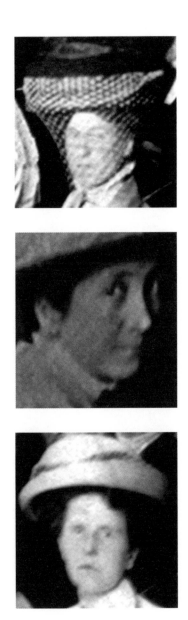

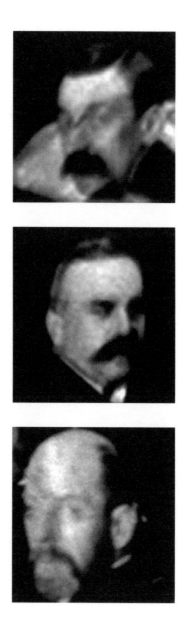

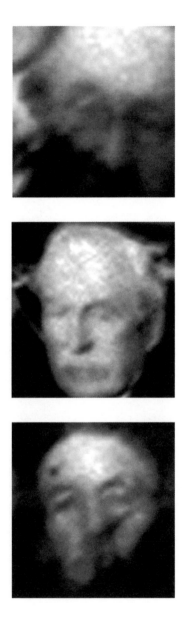

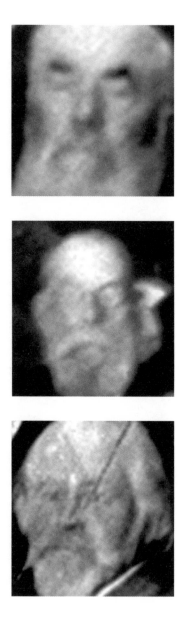

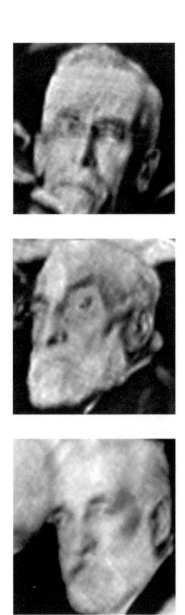

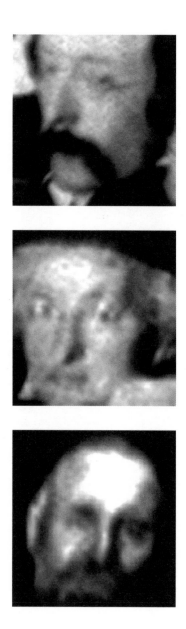

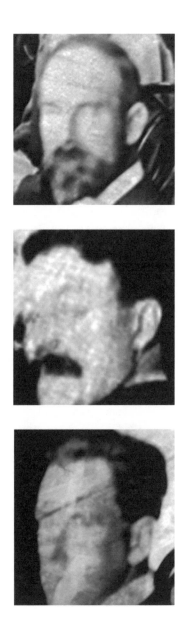

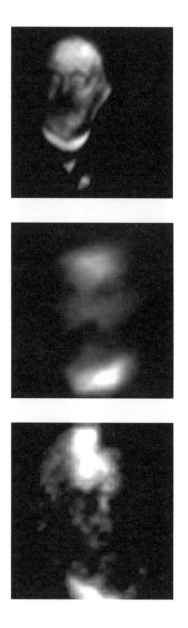

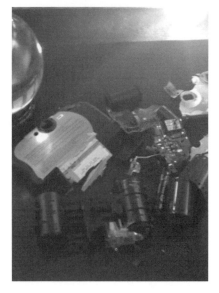

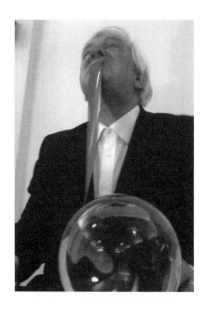

Coming to the Crossroads

IAIN SINCLAIR

You park in the middle of nowhere, letting the engine cool. Chill glass, *the viewing panel in a coffin*—fogs with warm breath. Metal ticks: a wasp trapped in a tin leg. You have been here before. Been everywhere in this part of the city, old London, ghost-terrain beside a working canal that no longer works. They have a laminated information board, fixed history, to let you know where you stand and what you should be thinking. Memory is preordained, decided by professional explainers, edited by committees. You crank a handle, the map speaks in the voice of Maud Winnington-Ingram, a parson's daughter, born in 1880. While you crank, she utters. When you stop, the voice dies. 'It's strange, my first encounter with the canal was...'

I laboured here in 1974. Spring, summer, autumn. In early winter they let the casuals go or found some excuse to dismiss them. I cut grass around the Hawksmoor churches—St Anne's in Limehouse; St George-in-the-East on the Ratcliffe Highway—and I spiked rubbish, picked up broken glass, the discarded sherry bottles of vagrant drinkers. (The rector could be found in the vanished pub, the Blade Bone. We shook keys from his waistcoat pocket, to explore tower and crypt, spidery catacombs where our whispers were swallowed by the stone.) This warehouse building, viewed across a wilderness meadow, was busy with forklift trucks, pallet boards, cans of dubious provenance; outdated meats for the shelves of cut-price minimarkets. Now sodium light blazes. And dancing figures shift into negative.

Two thousand cubits from the crossroads. Do you know what a cubit is? 'An ancient linear unit based on the length of a forearm, from elbow to the tip of the middle finger'. But who, in these last days, walks on their arms? What creatures scuttle into the undergrowth, thorns through their lips, mud-suckling? Chewing bones and shreds of spittled tobacco. You have to take that measure, an element of London's sacred geometry, on trust. Cubitt is the name of a speculative builder. William Cubitt laid out the railway that linked Blackwall Dock and Tower Hill. He had his own settlement, his brand on the city: Cubitt Town at the south-east corner of the Isle of Dogs. Tower Hill was once the place of execution, for traitors and malcontents, preachers of false doctrine. A gazing mob freezes the moment when human heat ventures in a gush of blood. The place itself, just outside the bastion of the Tower, is earth heaped over the head of the buried Celtic giant, Bran. A myth of the founding of the city. A head, its eyes eternally open, watching the river. Gaudy ribbons of flesh attended by ravens.

All measurement starts from this site. Tower Hill is backed by the white stone of the old Port of London Authority building, an angular Byzantine temple in which every ship coming up the Thames was recorded, nibs scratching on parchment. *Motion like that of automata and images.* This story, our city, is all about heads. The man walks, a penitent, round and round the squared room—and my face, shifting, rolling, walks with him. Iron-shod heels ring. His mad eyes shine. He breathes hard. You can see a chipped tooth held in his open mouth like a bad penny. Through blocked nostrils, knotted with black hair, he sniffs quim and quicklime.

Emanuel Swedenborg, twenty-two years old in 1710, takes passage from Göteborg to the port of London. A sorry sequence of annoy-ances, delays, mental trials. Plague warnings, quarantine: Wapping Old Stairs. He comes in on the Thames tide like an ugly rumour. Sheep-head scientist, holy fool. Celibate enquirer. The youngest of the dead. A walking corpse with peach-fuzz on his cheeks. He hunts the soul to the innermost recesses of the body. He is fetched. As they

are all fetched, these visionaries. To lay down memory-traces in the clay of London. Reveries, posthumous visions. The reflex star-spurt of the hanged man.

Swedenborg, a talkative skull, is frantic to be buried alive. The spirits were deceitful. He saw what they saw; he saw through their eyes. A New Church, Jerusalem, must be made on this meadow: earthed, fitted with towers, lanterns, octagons, domes, urns. He was 'Samson shorn by the churches'. Barbers shaved vinegar eggs in his honour.

He slips ashore, a man forbidden. The plague-ship is tied up at Wapping, under a six-week prohibition. He is caught. He should have been dosed with gin, hung in chains while three tides washed over him. He has privileged connections: Erik Benzelius, his brother-in-law, is a bishop. He is saved, condemned to live. He is appointed the double's double, the Xerox pilgrim soliciting misinterpretation.

Emanuel has an 'immoderate desire' for knowledge, for the pressure of libraries, skills to master: lens grinding, clock-making, book-binding. There are machines to develop or to invent: submarines, blast furnaces, fire extinguishers, maps of the human brain. Every false step in the river-world opens an untested neural pathway.

Conventional, shrewd, affable, damned: the young man was a fugitive in the streets, the close alleys, chasms between warehouses. That time in his life is expunged. From the instant he stepped ashore, subtle time traveller, he was in suspended motion.

What he discovered survives to this day, a wild orchard. A thatch of white blossom. A tangle of broken boughs. Thorns, couch grass, berries. Between Cable Street and the Highway, to the south of Well-close Square, a green tunnel. A grove sequestered from the open ground in which is buried the rubble of the Swedish Church, Ulrika Eleonora. Persistent exploration locates a grey stone font on which the church is depicted as a black ark, a hostage to the furies.

Swedenborg was buried in a vault beneath this altar. In 1908 his body was exhumed and returned to Uppsala; out once more upon the river. The skull, so it is fabled, was mislaid. Does it wink beneath

the bar of the sewermen's pub, the Crown & Dolphin, with other contraband trophies: the caput of John Williams (De Quincey's artist-murderer), defaulting gangsters, the bone lanterns of the London disappeared? Or was the pillaged head fated to become a Masonic resource, boxed in black velvet in the depths of Queen Street?

The boy, the stranger, lies on coarse grass. His back rests against a gnarled tree. Dappled sunlight. Shadowplay on white, outstretched hands. Swedenborg's soul is resolved into discrete points of motion. It is of one substance with the sun. He is diffused, lost, estranged from himself. No longer does he converse with the legions of the dead. He died, here, and became one of them. He remembered what was not yet known. Then he raised himself up, brushed his long jacket, and walked away. Leaving his hat hanging on a tree.

William Blake challenged him, recognized his spirit. Two thousand cubits from Tower Hill to the demolished Wellclose Square. To the crossroads where they buried John Williams, head removed, stake through heart. Swedenborg Gardens: a block of deadpan, East European housing, occupied by termites, invisibles. Wellclose Square has a suspended history of alchemists, seekers, visionaries, quacks: the Kabbalist Chaim Jacob Samuel Falk, maker of golems, collector of Thames mud. When the ceremony had been completed—oil of eggs, wax, amber, sage, cloves, tartar—Swedenborg appeared, celestial messenger. A northern golem of moonlight and dust. The confirmation of Falk's instinct: that he could raise the dead.

Emanuel is staying at the King's Arms, a property managed by a fellow Swede, Erik Bergström. Bergström keeps a journal. His paying guest, so he reports, dresses in velvet, breakfasts on black coffee, strides out every morning. The diary does not mention the visit to Falk. There were unrecorded discussions, scholars conclude, on Kabbalistic sexual techniques, lunar orgasms achieved by meditation on the letters of the Hebrew alphabet. Swedenborg builds a clock for accurately calculating time at sea (where there is no time). He comes to the crossroads, Cannon

Street Road, Cable Street. He is the supplicant and the one met, the summoned other. *I held out my hand, and the horrible, soft-spoken, eyeless creature gripped it in a moment like a vice.*

The nocturnal theatre, yellow windows, red light, is reflected on the curvature of the fogged windscreen. In the now deserted warehouse, beside the canal, our conjuror—a music-hall ghost, Tommy Cooper possessed by the spirit of Joseph Beuys—unveils the prophetic head. He says it is the masque of a savage mandarin. He says his name is Coad. He says leucotomy has greatly benefited physical coordination. He dresses for the evening's performance in a long blue cloak spangled with silver crescents and lined with red velvet. He says it's all a cod, a mismatch, a cockling.

Friar Bacon constructed a head of brass and coaxed it to language. If this can be called language, throat-harping, gutter-gobbed phlegm notes. The performance artist, in a dumb time, draws back his cloth of gold to reveal a head sculpted from industrial sausage-meat and fresh sawdust. He digs it with dirty fingers and offers scraps to the silent ones. The invisible communion. The hatted, feathered audience, in their austere pews, fused into one being by a sudden shock of light. *He shall send His angels and they shall gather together His Elect, from the end of the heavens to the end thereof.*

Publishers' Note

✿

The images, texts and transcripts included within this book are from Section J/78 of the Swedenborg Society archive. Part research document, part lecture transcript and part archive intervention they map and reconstruct an exhibition and event staged by the artist/ poet Brian Catling and the writer Iain Sinclair at Swedenborg House on the 17th of February 2010. Nine items are listed in the Swedenborg catalogue, six of which are published here: the missing three are a broken instamatic camera, a crystal ball and a roll of 35mm film.

One further item, the centrepiece for the performance and exhibition, mounted and framed, remains in situ on the second floor of the Society's grade II listed premises: a group photograph, in black and white, dated February 1910. With the exception of the sections 'Eyes No Eyes' and 'Commentaries' (which contain notes accompanying the exhibition and reflections gathered in the process of researching the Society's building, library and archive) the order of the contents follows the chronological sequence in which they were presented during the performance.

For their help and support we would like to thank all the staff at Book Works and the Swedenborg Society particularly James Wilson, Nora Foster, Holly Catling, and for design imput James Brook. The title *Several Clouds Colliding*, provided by Brian Catling and Iain Sinclair, is from Swedenborg's *Conjugial Love*, first published in 1768 as *De Amore Conjugiali*. A short inscription from this passage is included in the epigraph. The photographs accompanying Iain Sinclair's 'Commentaries' are by Anonymous Bosch and were commissioned especially for this volume.

Several Clouds Colliding

BRIAN CATLING | IAIN SINCLAIR

Published by the Swedenborg Archive and Book Works, 2012
Distributed by Book Works
Co-Series: Book No. 2

ISBN 978 1 906012 41 0

Edited by Stephen McNeilly
Artwork and book design by Stephen McNeilly and James Brook
Printed by TJ International, Padstow

The Swedenborg Archive
Swedenborg House
20/21 Bloomsbury Way
London
WC1A 2TH
www.swedenborg.org.uk
tel: +44 (0)20 7405 7986

Book Works
19 Holywell Row
London EC2A 4JB
www.bookworks.org.uk
tel: +44 (0)20 7247 2203

Book Works is funded by Arts Council England